How to Draw Manga

Character

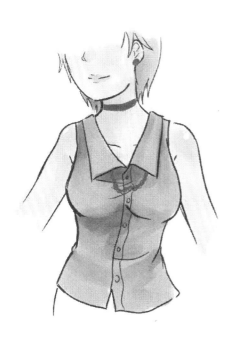

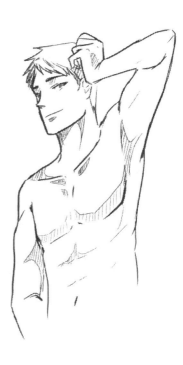

Table of Contents

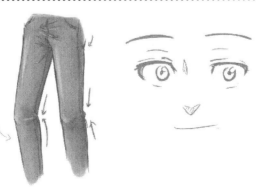

PREFACE

Hi. If you're starting out and a beginner in drawing anime characters, this book is especially helpful for you. Not only it shows step-by-step on how to draw a character, it will also help you develop your own style of drawing!

You may have been envious of other people's drawing or may have been interested in animes that you want to also learn how to draw your own. Before you start, remember to have fun learning. What are contained in every chapter of the book are techniques you can do to be able to draw your own character easier and faster. They are techniques but it doesn't ensure that you will get it at first try. There will be times that you'll feel annoyed or irritated that you don't get it as fast as you expected. But remember, every artist out there didn't learn how to draw well instantaneously; they learned to draw by drawing for weeks, months, and years!

Persistence and "stick-to-it"-tiveness are the key to learning anything and it is applicable to learning how to draw as well.

Accept the fact that you need to learn and from there on, you will be more eager to absorb the techniques. But never, never, NEVER forget the one thing in drawing anime....It is to have **fun**!

About The Author

Andrew Harnes is an inspiring author who came from a humble background. He has grown from a small town with a family of four. Early in his life he moved from a rural environment into the largest city, New York.

With the astounding amounts of efforts changing himself and developing into his best self. He pushed farther than he has ever before. He practiced to self-development, spirituality, working out, art and drawing religiously.

He learn to express himself with drawing in many ways. He knows that the journey of mastery is a never ending journey with great rewards and requires massive enduring.

He have a huge desire and passion to help those who are on the same path, he intend to share his wisdom and knowledge and seek more ways to help people unconditionally.

Chapter 1

Materials When You're Starting Out

Hi! If you're starting out in drawing, you must have the basic materials and know what they are for. But it's ok if you don't have them all but having them will surely help you learn how to use the different materials effectively and efficiently.

Pencil

Of course this is a given. To any artist who is just starting out or already an advanced/expert, this is a basic and necessary tool in drawing.

But do you know that there are different kinds of pencils depending on the hardness and softness of the lead. Pencils can be categorized into "H" pencil and "B" pencil. If you're going to check out some

pencils, you'll notice "3B", "4B", "2H" or "6B". These determine the hardness and softness of the pencil.

As the number becomes bigger, the softer or harder the pencil is. For example, 4B pencil is softer than 2B and 5H is harder than 4H.

But what use is the knowledge of that and the kinds of pencils to you? Well, you see, when you are drawing an initial draft, it'll better to use H pencils since they don't smudge that easily compared to the B pencils, thus it'll save your illustration from getting messy.

Eraser

An eraser is extremely useful when you're using a pencil. It is used to erase the unnecessary and unwanted pencil lines when you're already done with the initial/final outline (using a pen or heavy strokes of pencil).

Pens

Pens are commonly used in finalized outlines of the drawing. Since they cannot be erased, it is important to take care of any errors when applying it to the illustration.

They vary in the width of the pen point. The thickness of the pen is important to note because it is preferred to use thinner lines for details and thicker lines for the outlines.

Coloring materials

Watercolor is a nice coloring medium for an illustration but it is preferred to use it after drawing the final draft using a pencil and before applying the final outline using a pen. It is because it may smear the pen ink and cause mess.

Color pencils can be used with watercolor (after the water color has dried off) or they can be used without. You can use this even after drawing the final outline.

Chapter 2

The Fundamental Elements of Arts

The tendency is that you may want to skip this part—but NO. Knowing the fundamental—or basic—elements of arts is especially important when you're starting out in drawing. Why? It is because from the start to the end of drawing, you'll be using them.

These elements compose every drawing and art. What are these elements? These are dots, lines and shapes. In this section of the book, we're going to discuss about what they are and how they are used. And as we go further the book, you'll see the importance of each of these.

Dot

Dot or period is made by just letting the point of your drawing media touch the paper. The harder the pressure

is, the thicker and sometimes, darker, the dot becomes.

It is used in stippling (a kind of shading where you use dots) and as a beginning mark for the line.

Lines

Lines are series of interconnected dots or periods wherein the ends do not meet. There are different kinds of lines, namely, straight lines, zigzag lines, curved lines, and wavy lines.

Straight Line

A straight line mostly signifies a horizon or a surface. It is also used in hatching and cross hatching (kinds of shading). It is also important in making the background and items such as when you're drawing tables, roads, doors, etc. An example is shown below.

Zigzag lines

Zigzag lines are series of interconnected diagonal straight lines wherein the lines are toward different directions. This kind of line is use to denote a sharp edge like a saw edge. It is also used in the designs of items such as clothes and walls. An example is shown below.

Curved Lines

Curved lines are lines that are smoothly bent line. This is a kind of line that is used to draw circles and oblongs. This is used in drawing eyes, mouth, face and other parts of the character body. It is also used in drawing backgrounds and items such as shoes, fans, etc. An example is shown below.

Wavy Lines

Wavy lines are series of curved lines that do not form pointed edge. It can be used to draw wavy hairs, clothes, plants, etc. An example is shown below.

Shapes

Shapes are composed of a line or lines wherein the end of the line closes at the ends thus producing a shape.

Circle

Circle is a shape with no corners and the radius (the distance from the center) to the surface is equal in all parts. It is mostly used as rough draft for the head like what's shown below. More than that, it is also used as rough draft for joints, hands, feet and hips (we'll discuss this in the further chapters). In regards to background, it is used as rough draft for trees, flowers, cup, etc.

 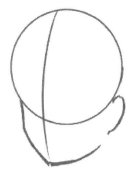

Oblong

Oblong is a shape that, like the circle, doesn't have any corner but the diameter (the distance between a side to the other side that passes through the center) of one side is longer than side adjacent to it. It is mostly used in rough draft for arms, legs, eyes (like what's shown below) and fingers.

 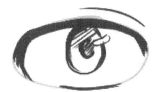

Triangle

Triangle is a shape that has 3 sides. It is used in the rough draft for the body and even to the eyes but mostly, it is used in backgrounds such as stairs and inclination surfaces.

Square and Rectangles

Square and rectangle are 4-sided shapes. Square differs from the rectangle in a way that in square, all sides are equal in length. It is mostly used in backgrounds like in drawing the window (as shown below), doors, buildings, etc. But is can also be used in the rough draft of the face and body especially when it comes to proportions.

There we are, though there are polygons (many sided shapes), these are the basic and mostly used elements in manga art. Though it sounds simple, it is of high importance since it'll help you build a solid

foundation on where to use which. Use these elements in studying the further chapters of the book.

Chapter 3

Do Warm-ups before You Start

It is easy to just go directly to drawing when you pick up your pencil and pen, and skip warming up beforehand. "What is it for? And why would I need to warm up before I draw? It's just drawing...," you might think.

Q: But what is for really? And why do you need to warm up before drawing?

Warm ups is like vocalization before the actual singing. It makes you hands and shoulder have the "feel" of drawing before the actual drawing so there will be a lesser chance of errors while in the process of drawing. Like in sports, warming up stretches up your muscles and registers in your mind the repeated motions you do.

Q: How do I start warming up?

Grab a pencil (or any drawing medium you plan to use) and a bundle of papers or a sketch pad. Stretch your hands and rotate your shoulders to loosen up your muscles and thus preparing for the actual drawing warm up.

Q: What are some starting warm ups I can do?

There are several kinds of warm ups you can do. But to start, draw <u>series of straight lines</u>. Use shoulder movement in drawing. Also, strive to make it equidistant or of equal distance from each other. Then try it with decreasing pressure.

After practicing series of lines, try drawing ellipses (circles and oblongs) from thinner to broader. Again, use shoulder movements not just wrist movement when drawing these ellipses. Do it as much as you want until you are confident that your ellipses are getting better than when you started.

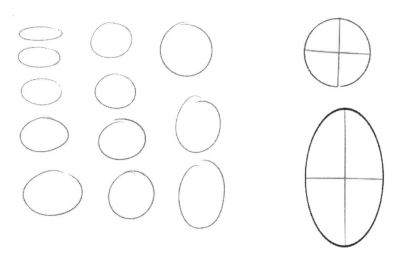

Q: Are there warm ups that aims to improve my strokes?

There are warm ups for different improvement focus. Some of these are to help you improve your strokes and help you control your strokes. How? As beginners, go on to making curved lines and wavy lines. Like the previous ones, make series of these lines. To learn control, you can make the distance equal or decreasing or increasing. Then you can also do swirls.

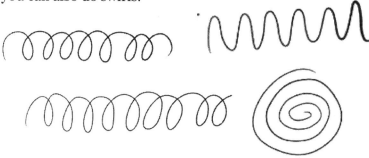

Q: What more can I do when I have done the previous warm-ups?

You can now combine the previous elements and form basic 3-dimensional shapes. You can start with cubes. You can use perspective in drawing them or just draw them free floating.

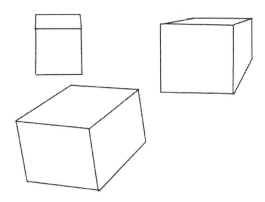

If you haven't heard of 1- or 2-point perspective, it can be explained by using 1 or 2 vanishing points along the horizon (drawn by using horizontal line). From the vanishing points, draw lines emanating from them to the front edge of the cube or the shape. Use these lines as basis for drawing the line. The point of using this is to ensure that your perspective of drawing the shape is right.

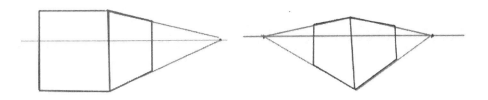

Next, you can make 3-dimensional cylinder. You can make it free floating or using perspective method.

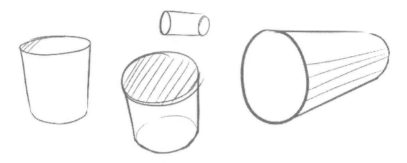

These warm ups are just some of the many warm ups you could do as there are more complicated ones. But these are the warm ups you could do as a beginner in drawing. Warming up is easy and you can do it even for a few minutes. It is important to warm up before you start and not to skip it though it's reaaaaally tempting to do so.

Once you get the habit of warming up before you draw, you'll see much faster improvement and you'll feel drawing easier.

Chapter 4

Techniques on How to Draw the Face --- Eyes, Mouth, Nose and Ears

The face is the first thing the viewers notice when looking at the character so if you want to make a good impression on the viewers about your character, you have to brush up on working on the face.

There are techniques on drawing the face as well as the other parts of the face such as the eyes, mouth, nose and ears. These will be covered separately. Also, how to develop your own style will be discussed and shown since we're not just going to show you the step by step of how to draw this part and that part, we're actually going to develop YOUR OWN STYLE depending on how you want it to be. This will be applicable not only to the face but also to the rest of the book.

What will be discussed here are the techniques you can use in drawing the character and how to develop your own style.

Face Outline

When drawing the face outline, it is important to start with basic shapes. Here, let's start off with the basic parts of the face outline, then we'll go to how to draw the different perspective later.

First thing to always do when drawing a face is to **start with a circle**. It doesn't need to be a perfect circle but preferably if you can make one.

It is also important to note that when drawing the draft of the face, draw with light pressure only using a pencil so your art wouldn't look messy when you put the outline and all. It should almost be non-existent but you should be able to see it or else it wouldn't serve its purpose. Its purpose is to guide you on where to place the parts of the face as well as to guide you to how to draw the outline of the face.

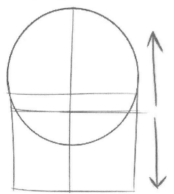

Next step is to draw the **center line** (the vertical line) and the **eye line** (the horizontal line).

The center line defines where the face is facing. If it's in the middle, then it is facing fully in front. If it moves to the left or to the right, it means a change of perspective. Imagine turning your head to the left or to the right. That is the principle in that.

The eye line is the horizontal line in the middle of the face. It is really important to note that it should be placed as a mid line between the top part and the lower part of the face. This line, as the name suggests, is where you will put the eye.

In drawing the jaw line, you could experiment on that. It is better if the side of the jaw line is somewhat diagonal.

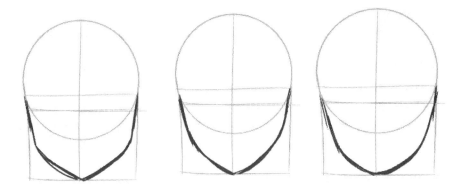

But it is important to note the common errors in drawing the face outline. Here are some of the most common errors beginner artist make:

- The outline of the side of the face is so vertical that it looks like a box. It'll look edgy and...weird.
- There is unequal left and right side of the face. It'll definitely look weird when that happens because it'll look...alien...and asymmetrical.
- The face outline is somewhat triangular. It makes the face look like an ice cream. It is weird and is definitely a no-no.

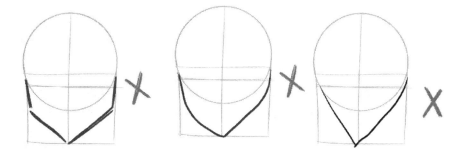

EYES

The eye is the mirror of the soul and so, it mirrors the personality of the character. It is obvious to any anime fan that it defines the character and it's one part of the face that almost always get the attention.

But to most beginners, drawing the eyes is a challenge...moreover, to draw both eyes proportionally. I was a beginner once so I know what you are facing. So I'm going to show you some techniques on drawing the eyes.

Using Oval as Guide

There are advantages in using this technique. First of all, the oval will serve as the guide of how long the eyes will be so if you just make 2 oblongs of same length and height (if it's facing front) for both the eyes, it'll be easy for you to draw 2 proportional eyes. Plus, it'll look good and smoothly done.

What is shown here is just the principle of this technique. You are free to experiment so you can develop your own style.

Let's first focus on one eye---the left one.

First and foremost, draw an oblong using your pencil lightly. You can actually vary the oblong to your desired eye shape but here, we'll just draw a normal oblong. It doesn't need to be perfect. This will serve as a guide for the eyelashes which defines the eye shape.

Then, for the draft of the cornea, draw a circle of your desired size and position.

Using the pen or a pencil, draw the outline of the top part of the eyes.

For the lower eyelid, draw a line along the lower part of the oblong.

For the inner part of the cornea, draw the iris as a circle. Then you can add where you want the light effect to be. This light effect on the eyes will give life to the cornea. You can make it as a circle or an elongated oblong of your desired size and form.

Afterwards, start drawing the outline of the cornea. You can use thick lines or thin lines depending on your preferences.

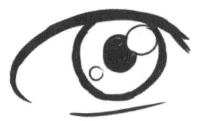

Then draw the iris and the light effect on the cornea next. Erase the draft lines.

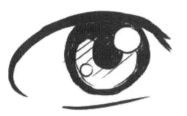

Here on, you can personalize the eyes you are making. As a tip, the top of the cornea is darker than the lower part. Also the side is darker than the middle part.

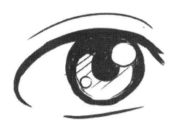

To make a double eye lid, add a curved line on top of the eyes. It'll give more appeal to the viewers.

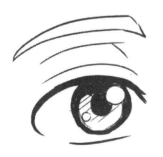

Add depth to the eyes by putting a crease on top of the double eyelid. This is optional.

Also draw the eye brows. You can draw it thick or thin depending on your preferences.

Using "V" as a Guide

Using the letter V as a guide has its advantages. Though it won't be as easy as using the oval as guide, it is advantageous in a way that it can help you experiment more on your style as well as to guide you if you prefer the eyes to have pointed ends.

How to do this? And what will make this work?

The thing that will make this work is to stick to the guide. The principle here is that you should place the eye inside the V having the top eyelid and the lower eyelid touch each side of the V.

The first thing to do is to draw your V. The bigger the angle, the longer and thinner the eyes become as shown below. You'll also follow the same principle as the technique in using the oval as guide.

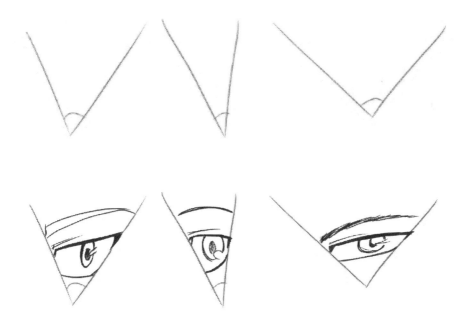

After drawing the V, draw the first eye lid. This will give the eyes somehow a similarity with the realistic eyes.

Then add the rest of the eye lid. You can experiment in here. Here are just some of the other possible eyelids you can make:

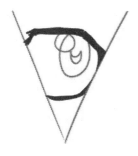

Draw the lower eyelid. Afterwards, for the cornea, do the same as what you did on the previous technique. Draw the cornea, then draw the iris (you can also experiment on this, but usually, it's a circle or moon shaped). You can add light effect so the eye would look alive.

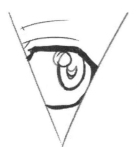

Draw the outline of the cornea. Then draw the double eyelid and the depth of the eye on top of the primary top eyelid.

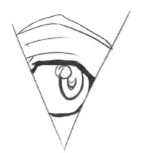

Then draw the eyebrows. The edges of the eyebrows should be drawn touching the edge of the "V" like what is shown on the left side.

Where to place the eyes?

Placing the eyes might be difficult for beginners. Remember in the first part of this chapter that the eye line was discussed? Use that line to know where to place the eyes. The line should pass through the latitude middle of the eye while there is an equal distance from the center line to each eye

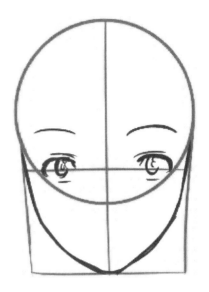

EARS

To beginners, ears are drawn as half circle near the eyes but to improve on drawing the ears, that's where you will start.

As shown below, a semi-circle is lightly drawn using a pencil. Then the outline of the ears is drawn next. You can follow and copy how the ears is drawn below. But when you get the principle of drawing the ears, you can experiment on your style and apply it on your character.

Here it is shown the basic creases in the ears as shown by the red arrows.

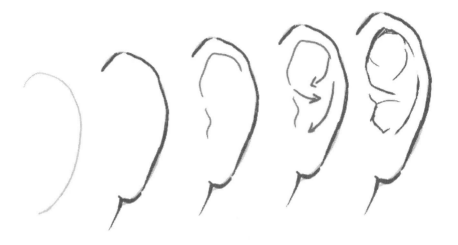

Where to draw the ears

In the guidelines of the head which we have shown, there is a line that runs through the half of the face—that is where the top of the ears should touch. The size of the ears varies though, so what you can do is to increase the length of the ears downward and the width sideward.

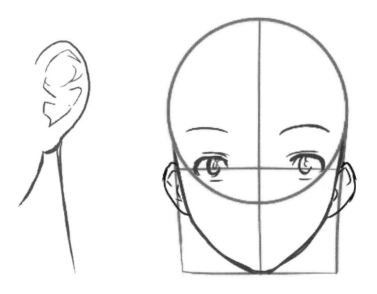

NOSE

The nose can be drawn as non-existent at all. But of course, if you're planning to draw an anime character, it would be better to learn how to draw the nose since it will give more appeal to your character. The style of how you draw can vary depending on your preferences.

Here's the basics of how to draw the nose.

First of all, note that the nose is raised than all the feature of the face and that it is placed in the middle of the face along the center line.

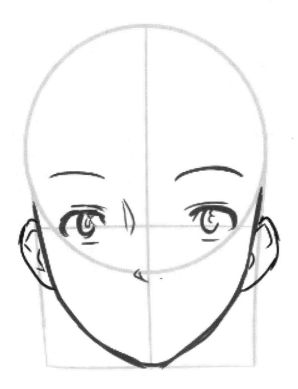

You can try some of these kinds of noses. It is also shown how it looks like in the face of the character. You can play with the shadow by hatching (a kind of shading using series of lines) the side of the nose or even under the nose (depending of course on the source of light). You can try drawing the 2 holes of the nose for a more realistic touch.

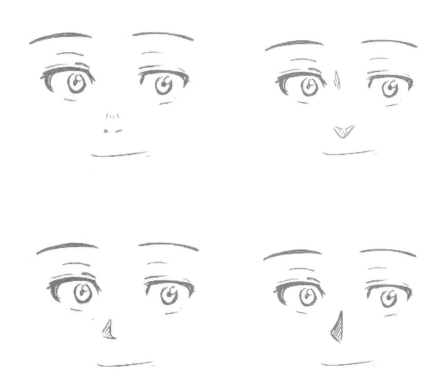

Here are more noses you can try.

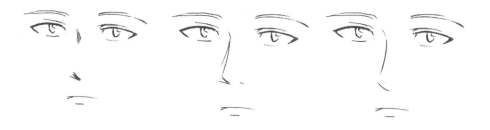

MOUTH

The mouth is an important part of the character because it shows expression along with the eyes. It varies in style, the degree it is open and the length.

But here are the basics on how to draw the mouth. First of all start with the basic elements.

Then, add the guideline for the tongue and the teeth. If the face is forward facing, the tongue should be placed along the center line.

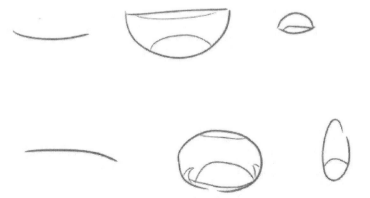

Then, draw the outline of the mouth. You can put your personal style in drawing the outline. It can be less detailed or almost realistic or somehow in the middle of both. You can place some creases in the top and bottom of the mouth or none at all. You can also put some shadowing by hatching inside the mouth to show depth or you can just make it simple. Feel free to experiment.

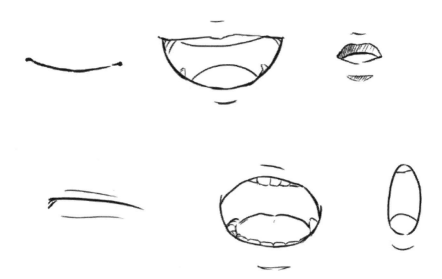

Where to Place the Mouth

To beginners, this might be a challenge to you. You might place it somewhere too near the nose or too low. But really, where to place it?

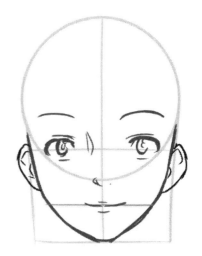

There are some tips on where to place the mouth. First of all, there should be a proper distance from the nose. Next tip is to make a draft line along the jaw and that it where the mouth is preferred to be

28

placed under.

The length of the mouth should not exceed the middle of the eye position and the edge of the mouth should not reach higher or near the nose when the face is facing forward.

Studying how to draw the face is just a step on how to draw your character but it is never less important as the other parts. It is important to study this since it gives personality to your character as well as to show you how enjoyable drawing is.

Use the techniques and tips on drawing to make it more fun and easier.

Chapter 5

Drawing the Face in Different Angles

Now that you already know how to draw the parts of the face and the outline of a face, you're ready to proceed to learning how to draw the face in different angles. To beginners, drawing the face in different angles is hard but actually it's easy to do especially when you apply the techniques that will be taught.

One thing that you should do is always practice drawing. When you learn and master this chapter, try applying it in your warm ups before you draw a whole character or even your own manga. As you go through this chapter, have fun and enjoy learning and most especially, drawing.

Side view

Side view is most common angle next to front view that beginner artists draw. Yet it is also the stumbling block for most of them. How do they commit errors? It is because they don't use guidelines or draft before they draw the face.

Here are the parts of the draft of the face in side view.

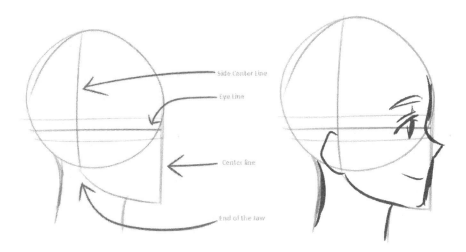

Where to place the different parts of the face?

When it comes to changing the angle to side view, most becomes puzzled as to where to put the parts of the face. One easy way to determine is to draw the front view and the side view side by side during the warm ups so you can recapture and put into memory what the side view of your character should look like.

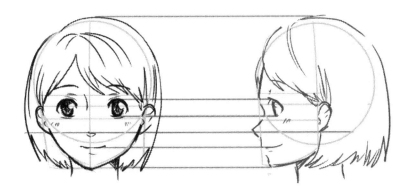

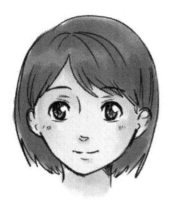 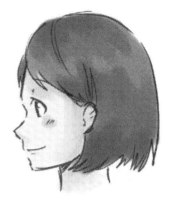

The head can also tilt to different directions but once you know the parts of the draft of the face, it'll just be easy to do. Just remember that the center line and the eye line are the basis of the direction the head is facing. The intersection of the 2 lines form a cross making it easier for you where the head is facing.

Here are some of drafts in different angles:

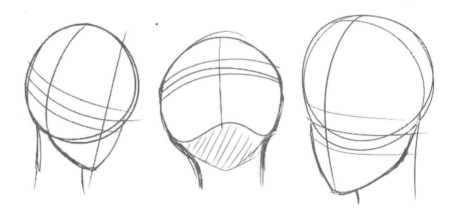

Three-fourth View

Now we move to drawing the three-fourth view of the face. Here we tilt the head towards the side in such a way that the other side of the face is shown but smaller than the other side. It is because of the

principle that the farther the object/part of the object, the smaller it seems to the viewer.

We see here that the other eye which was in the farther side of the head is also shorter in terms of length. Also the distance between the eye and the center line also decreases in the same proportion as the degree of angle.

The principle is also applicable to the mouth and the ears. Use the eye line to determine the position of the eye. Shown below is an example of the principle applied.

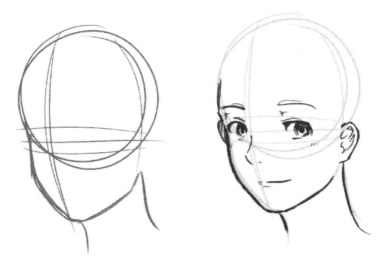

How to Draw the Face Elements in Different Angle

When doing the angles of the face, you may find it also challenging to change the eyes, the nose and the mouth according to the direction the head is facing. The eyes should not just be flatly put there. It should also adapt to the angle of the head and since the head is somewhat round, it adds to the challenge of making the elements also angled.

For the eyes, one way of eliminating that is to use ellipses and the eye lines. When the head is facing up or facing down, the eye lines becomes curved down and curved up. It's not just straight ellipses anymore.

Is it still hard to understand? Imagine the surface of a cylinder and imagine that there is a horizontal line drawn on it, when you tilt it upwards, the horizontal line isn't just horizontal line anymore. Same principle applies to the face.

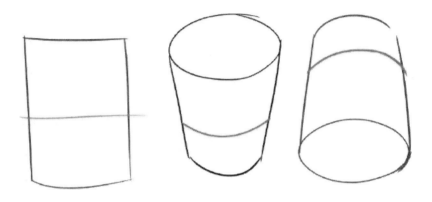

In applying the principle to the head of the character, the eyeline and the other face lines should look like these:

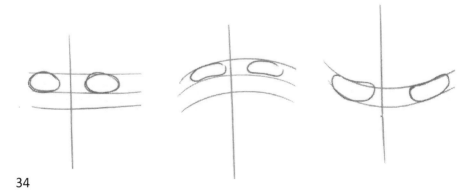

And thus, when drawing the eyes, the eyelid and the eyebrows adapt according the curvature of the eye line.

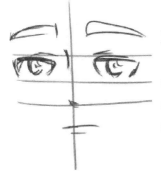

<u>When facing forward</u>. The eyes and the eyebrows are placed in a normal way and position. The distance between the eyes and the eyebrows are normal. There is no change in the elements of the face.

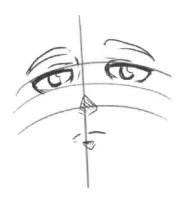

<u>When facing up.</u> When the head is facing up, the eyes, following the form of the ellipse from what was before shown, is curved up and the distance of the eye from the eye brows seemingly decreased and so are their height. Part under the nose is shown (the amount of the nose is shown depending on the angle). The mouth is also curved upwards.

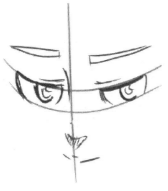

<u>When facing down.</u> When the head is facing downwards, the eyes and eyebrows are slightly curved downwards; the height of the eye is also smaller than that of the normal view. The nose is placed farther from the eyes and so is the mouth. The mouth is slightly curved downwards.

Chapter 6

How to Draw the Hair and Different Hairstyles

Have you ever gotten so frustrated about how to draw the hair? And when you look at artworks, you'll wonder how the other artist know where to draw the hair and how they added those intricate details?

There are some steps you can do to make it easier for you to draw the hair. It will not only help you how to draw certain types of hair like what will be shown as examples, but also give you the principles that will enable you to draw your own character's hairstyle.

Basic Steps of Drawing the Hair

1) First and foremost, before you start, take note that the guideline of the head also shows the surface of the head in the top. It also shows where the ears should be and it makes it easier for you to

style your character's hair relative to the ear (like the hair draping in the ears).

2) Then draw the hair line. This will serve as basis to wear the edge of the area where hair grows. This line will be very useful in drawing the hair so never skip this part.

3) Then from the hair line, you can now draw the bangs or the hair that originates from the hairlines. Draw groups of hair depending on your preferences. Below is just an example of a LOT of different hair styles you can draw.

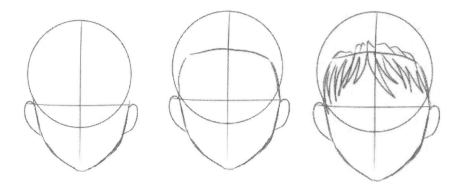

Here are some bangs you can do:

4) Next, draw the main outline of the outer hair. But how can you know where to draw it? Use the draft lines for the head. Draw the hair outline outside the circle as shown below. Imagine if you draw inside the circle, the head would look distorted and...you don't like that.

5) Draw the tip of the hair. This can be drawn as curved zigzag lines or even just lines.

6) Draw the detail of the hair. If you wish to draw details that would look like group hair strands, decide where the hair partition is. From there, you know where the lines should originate from.

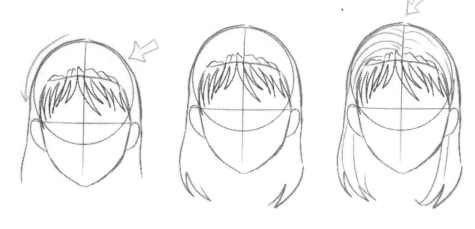

7) Add more details like more and thinner strokes. Erase the pencil lines.

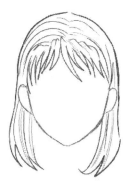

Drawing Irregular Hair styles

Drawing hairstyles in different and irregular style is hard...seemingly. But it's just what it seems. It is actually easy as long as you follow this technique.

In this example, it will be shown how to draw a hairstyle in which the hairs in front are "standing" towards different direction.

First of all, using lines draw the direction of the hair you are to draw. In the example the lines radiated from one point. Next, draw the outline of the hair by following the direction of the line you made earlier. The thickness of the hairs depends on how you like it and the character is designed.

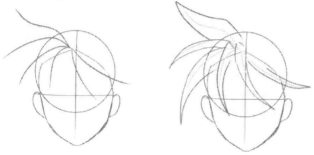

After that, draw the back of the hair. It can be long, it can be short, it can be pointy or it can just be round. You can play with it and experiment. In the example, a small pointy edge was drawn.

When all of the basic outline of the hair is drawn, add the details. You can play with the light by drawing connected and closed curved zigzag lines like what's shown below.

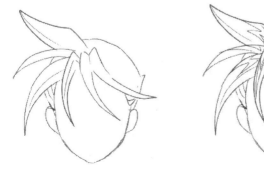

Drawing the Hair in a Different Angle

When you know how to draw the hair in face front view, it'll just be easy to learn how to draw the hair in different angle.

First, draw the draft of the head. When you have drawn the head in the angle you prefer, draw the hair line then draw the directions of the hair where you want them to be using lines as what's shown below. Then following these lines, draw the hair outline then erase the draft lines when you're satisfied with it. Note that the farther hair from the viewer, the smaller it should be compared to the nearer group of hair.

Finally, add the details like lines and light effects to your drawing.

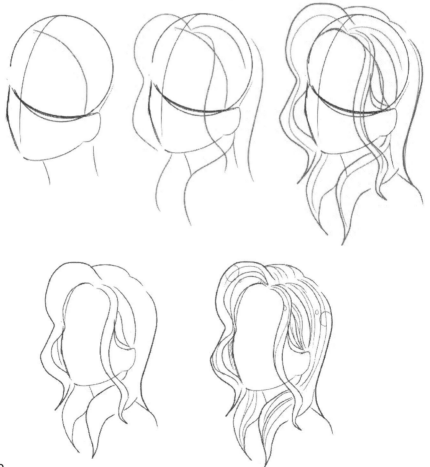

Chapter 7

Using the Anatomy Model in Drawing the Body– Hands, Trunk and Legs

After learning how to draw the head/face, drawing the body of the character is obviously next. From the beginning of the book, it is introduced the use of basic shapes and it is applicable even in this part. (Yes, it is that's why learning the fundamental elements of art is important!)

Drawing the Skeleton

What is shown in the left is an anatomy draft. How to draw this is simple. After drawing the circle for the head, draw the face outline. Draw a center line from the head going down until the end of the trunk (this can just be estimated).

How to draw where to draw the trunk from the head? The distance between the circle of the head and the trunk should be equal as the size of the circle of the head.

The trunk is classified into three: the chest, the tummy and the hips. All in all, the length of the trunk is equal to three circles of the head.

For the extremities, draw lines for the arms and the legs. Draw small circles to where the joints and the hands are.

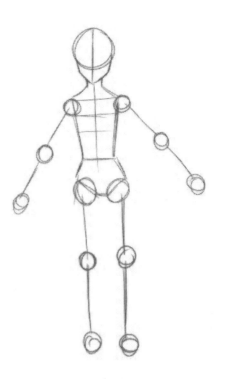

The length of the arm should be double the length of the top part of the trunk until the waist. And adding to that, divide that equally and you'll know where to put the joint for the elbow.

Now, drawing the skeleton for the legs is also simple. Draw lines for the legs and circles for the joints and the feet. The femur (or the upper leg) should be longer than the lower leg by half a circle.

Note: the total length of the legs is dependent on how tall you want the character to be.

Before we move on to adding the outline of the body, let's study how to draw the parts first.

Hands

To draw the hands, start with a circle then draw lines (for the fingers) from the wrist area. Then draw curvy lines like what shown on the right. This will serve as basis for where to place the joints.

Afterwards, draw the small circles for the joint. For the thumb, draw circle in the base, in the middle and in the edge.

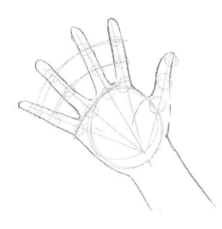

Following the draft lines or the "skeleton", draw the outline of the hand. Add some creases on the hand in the joint area and the thumb area of the palm.

Erase the pencil lines and add more details into the hand. And...viola! Hand!

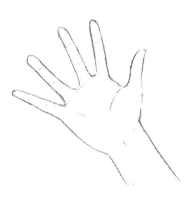

When the hand changes position, you still use the same principle. Start with the circle and draw the lines for the fingers and the circle for the joints. Then using the draft lines, draw the outline of the hand then add details.

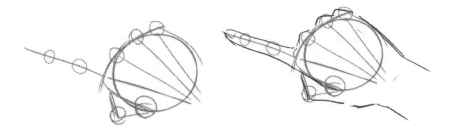

Feet

Next to the hands, feet has almost all the beginners confounded because it looks so hard. There is a technique, however, and it'll be hard at first but through practice, it'll surely help you in drawing the feet.

Start with basic lines. For the heels draw a circle. If the foot is facing forward, draw an oblong in front of the circle. When it's facing a different angle, place the oval towards where it is facing. For the toes of the feet, draw first curved lines as a basis where to place the toes.

For the side view, draw three (3) circles of different size. The heel should be twice the diameter of the second smaller circle. It's the same

with the second, with the third. The distance between the first and the second is equal to the diameter of the second. And this is, again, the same with the distance of the second and the third---the distance between the two, the diameter of the third.

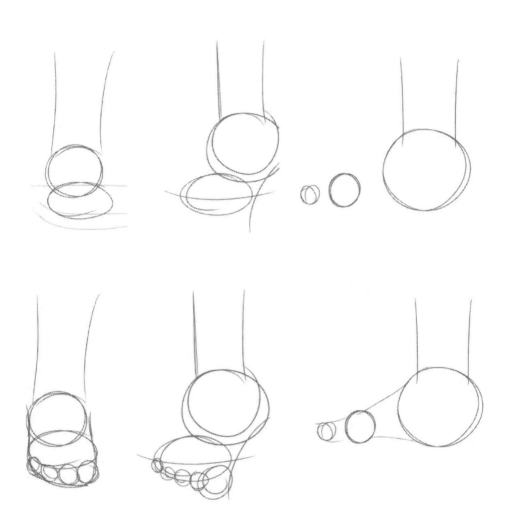

Then, using the basic lines as basis, draw the outline of the feet like what's shown below. In drawing the foot, you should consider which foot it is---whether it is the left or the right foot. If it's facing the left, the foot should curve towards the right, and vice versa.

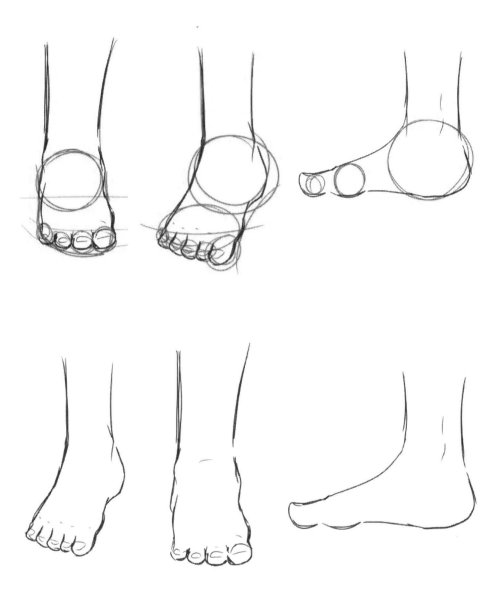

Trunk

The chest is one of the key differences between a female and a male character so learning how to draw them is important to differentiate your character.

Female

First and foremost, the female body is less rugged and smaller than the male body. It's curvier too. Given those facts, when drawing the trunk of a female, make the trunk curvy towards the waist line.

To draw the chest, draw two circles along the chest area. The size of the chest would depend on how big your circles are. Finally, after drawing the draft lines, draw the outline of the female body by following the draft lines.

Don't draw the chest by just drawing a semi circle. The lower part of the chest should be bigger than the top part.

Add the clavicle. It would help to make your character's trunk more real.

Erase the draft lines and add more details. If you're going to use this body as basis for the body of the female character, use pencil in lightly drawing the body outline.

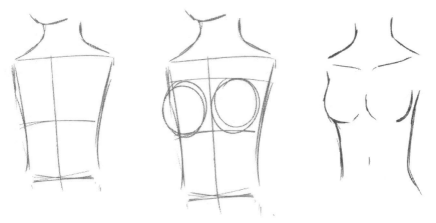

Male

In the drawing the male body, know that the man's body is more rugged and bigger than the female's body. It is also less curvy and the waist isn't as thin as the normal female's body.

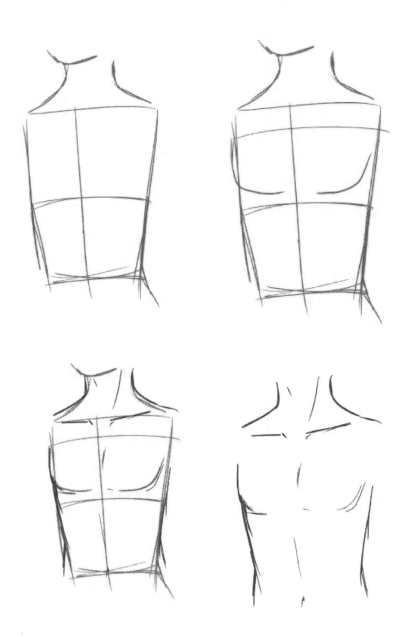

Body

Now that learning about the different major parts of the body was presented, it's now time to learn about how to draw the body all in all.

Female

From the first part of the chapter, it was shown the basic "skeleton" of the body. And following this, draw the outline of the body. Apply what you have learned in the previous parts about the trunk, hands, and feet.

For the female's body, you can see the thinner waist and the bigger hips.

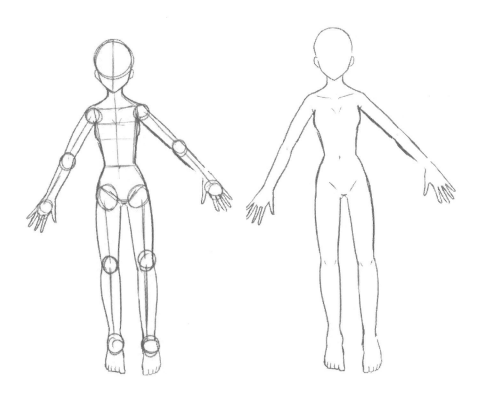

In the knee part, add two lines that show the position of the knee.

Male

As what was mentioned before, a male's body is more rugged and bigger than the female. The waist is also not as thin and the hips as big. Also, you can make the male body more muscular and bigger.

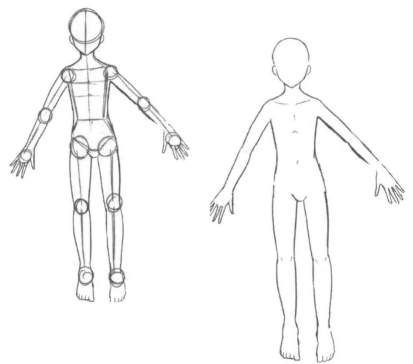

Backbone

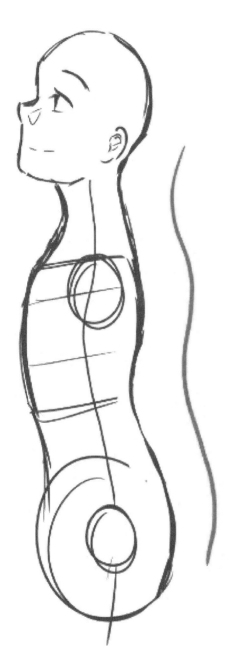

Before proceeding to drawing the character in different angle and movement, what is essential to know in the trunk area is the back. It should be smoothly curved. This is due to the natural formation of the back bone or the vertebral column. Since you character models after a human being, following this curve of the back will make it more real for the viewers.

In here, you can see that the back is not straight. From the neck area, the curve moves inward. However, as the line goes down, it curves outward near the shoulder area and it curves inward again in the waist area.

Then again, it ends by curving outward in the hips.

The backbone is curved this way for ease of movement.

Why do you need to learn this?

You need to learn this because it will be awkward looking for your character if it's as stiff and straight as a pole or a board. Moreover, learning this will give you more freedom in manipulating the movement of the character.

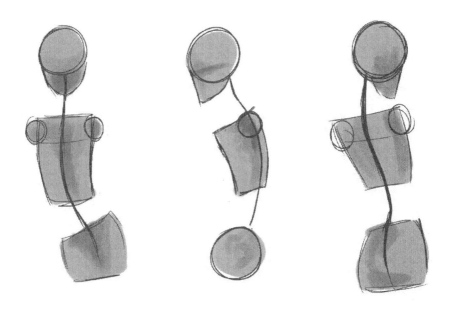

Side View

Following the same principle, use the basic shapes for the body. Use the same proportion as the front view again.

Draw a circle for the head. Then apply what you learned in **chapter 4** about the head. The distance between the circle of the head and the trunk should be equal to the diameter of the circle. Aligned to the ears and on the top part of the trunk, draw a small circle to show you where to place the arms.

Aligned to the ears, again, draw the lines for the legs from the hips part towards the feet. Draw a small circle for the joint of the knee. Then following the draft line, draw the outline of the character.

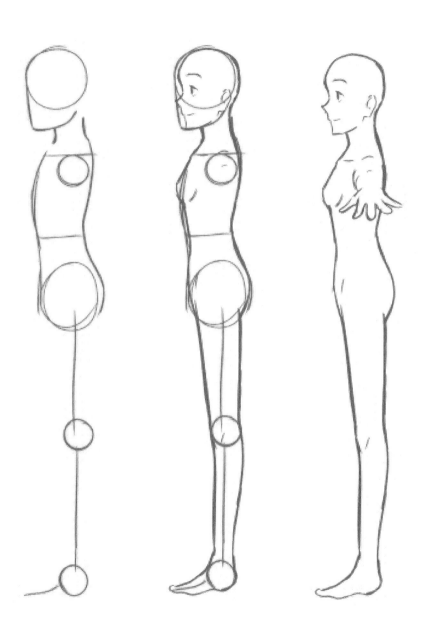

Chapter 8

Making your Character Do Some Actions

To give life to your character, actions are of really great importance. Without actions, your character would be lifeless. It will just be stiff and boring. But with actions, you can make your character more appealing to the viewers. Moreover, it would give personality and color to them.

Applying what you learned in the previous chapter about the body, here we'll apply the same principle except that there will be movements in the appendages, head, and/or the trunk.

What's shown below are some examples of drafts depicting movements and gestures. Here you can observe that the appendages bend in the joints (the small circles). Also, the movement of the trunk depends on the backbone (this was discussed in the last chapter).

What will be added and discussed here are the shoulder and hip line, gestures, appendages movements, trunk movement and balance.

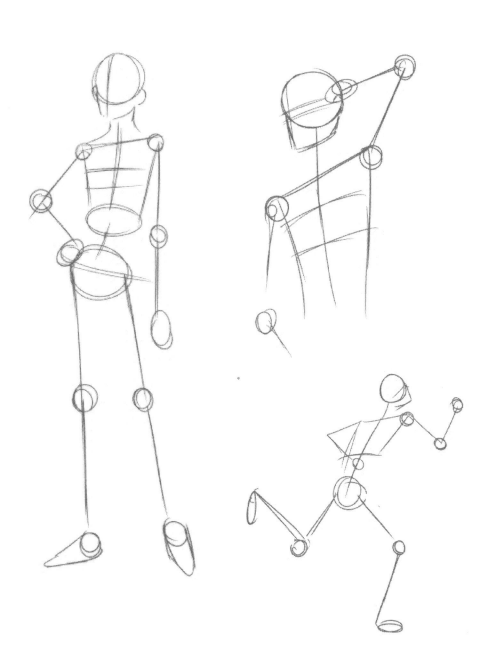

Shoulder and Hip Line

In addition to the basic shapes and lines of the draft line of the body, the should and hip lines are important. The movements of the shoulders and hips affects the curvature of the backbone thus affecting the whole form of the trunk like what's shown below.

The red lines are the shoulder and hip line while those that are black are the circle for the head and a line for the backbone.

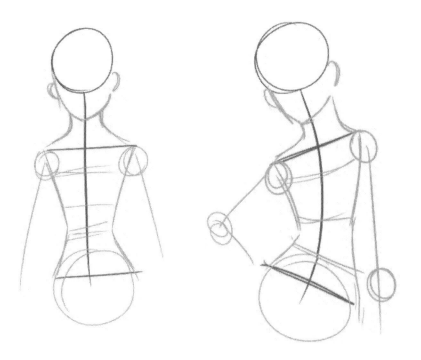

They are extremely useful when it comes to determining the movement of the character not only because it affects the for of the trunk but also because it affects the position of the appendages as well.

Just below the edge of these lines, the joints for the arms and legs are placed.

Appendages' Movements

The movements of the legs and the arms are important in the overall movement of the character. It is important to note that the movements of the appendages happen at the joint parts.

Arms

Start with lines and circles. The circles will serve as the basis where the joints are. This is also where the arms can be bent. In the arms, this circle will indicate the elbows. Then draw the ovals as how think you want the arms to be and draw the outline of the arm.

This principle is important and will be extremely useful when it comes to different intensity of movement. Knowing where the elbow will bend is also important so you won't make your character look weird because the elbow is either too low or too high.

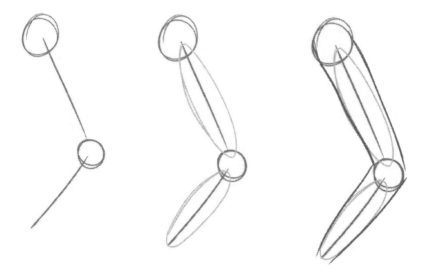

Legs

Drawing the legs is similar to drawing the arms except that the hips has a wider width and the lower part of the leg has a different shape (since the hamstring gives it that shape normally).

To start, draw the a circle slightly bigger than the other small circles. This will serve as the hip joint. Then draw a line slightly longer than the lower part of the leg since the thighs have the longest bone in the body (if you took Biology, you would know and understand that).

Then draw the ovals for the legs. The oval on the thighs should have the top part (the hip part) bigger compared to the other side of the oval. As for the the lower leg's oval, do the same. The top back part (nearer to the knee) of the oval should be bigger than the lower part (nearer to the foot). It is because of the calf.

When drawing the character, drawing the appendage following this principle would make it look more real and similar to the human body. This will make it clearer and for the viewers that the leg is a leg.

After drawing the ovals, draw the outline of the legs. How to draw the feet was already covered in the previous chapter.

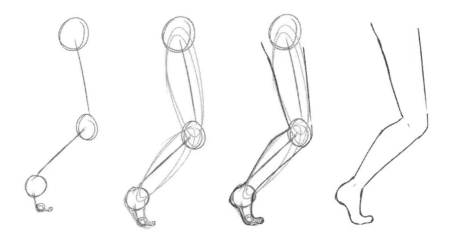

Here's another example of drawing the legs. It uses the same principle by starting out with the circles and lines. Furthering on to the ovals and then the outline.

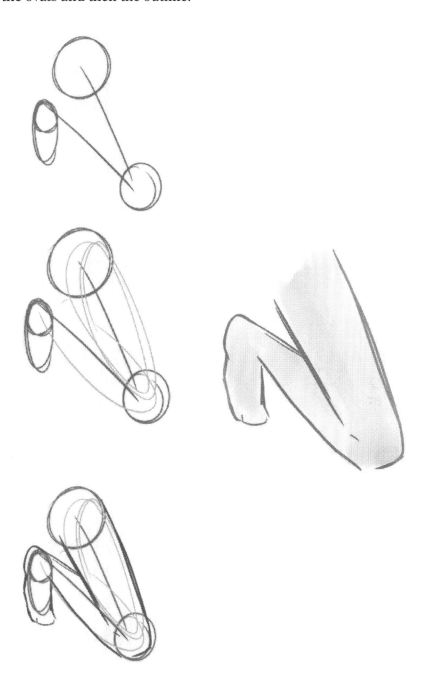

Gestures

Gesture movements include minor movements of the character used to express something. It may just be a simple movement of the finger to a large movement of the arms gesturing, for example, asking for a hug.

What is important here is the movement of the appendages and the head.

An example can be shown below.

As you can see below, the shoulder line is curved depicting a raised left shoulder. The joints are drawn under the edge of the shoulder line. Afterwards, draw the motion of the character by drawing the line of the appendages. The example below shows a man whose hand is in the side of the head.

Afterwards, draw the other lines for the fingers, the arms, the face, and the trunk.

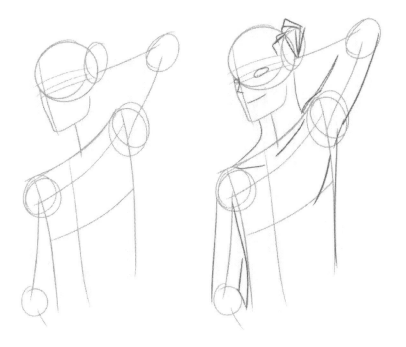

After drawing the "skeleton" the character, draw the outline of the whole body and the head then erase the draft lines. Draw also the details of the face.

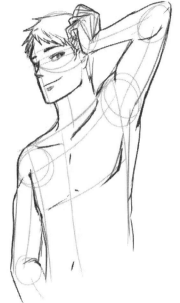

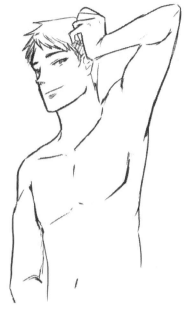

After that we can now see the gesture of the character. Add more details to your liking. Add shadowings by hatching.

There we go! A character the seems alive with his gesture. Isn't he nice?

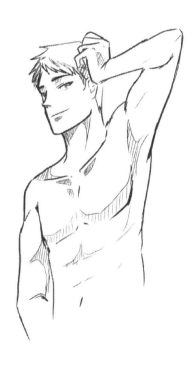

Drawing the Whole Character

At last, we're here in this part! This is where you can learn how to combine all that was covered into making the body outline of the character.

First of all, as the previous chapters have covered, start with the lines and circles as the basic and starting draft lines. Decide the pose of the character at the very start so it would not be too messy as you go through the process of drawing the character. This will serve as the "skeleton" draft for your character

Note these things while drawing the draft lines:

- the lines for the appendages should originate from the middle of the joints' circle.
- the circles for the breast should be placed just under the line in the top part of the chest.
- draw the hip joint as circles four times bigger than the normal joint circles.

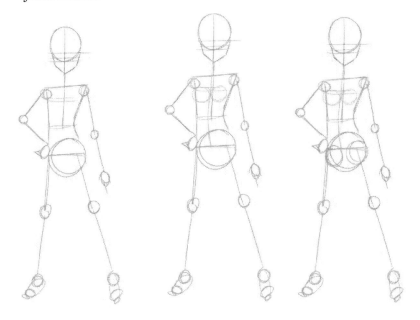

After doing the "skeleton", proceed to drawing the face. Remember what you have learned in **Chapter 4**? If you need to be refreshed about it, go back to it so it'll help for the information to be stuck in your mind and soon it'll be easy for you to draw the face.

In drawing the neck, for the girls, normally, it's width is one-third of the diameter of the face. But this could vary according to your style.

For the guys, the width would be half of the diameter to a whole diameter of the face—again depending on the style.

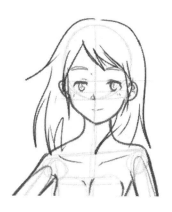

After drawing the shoulders and the face, draw the hair.

After drawing the face, draw the body. This was covered in **Chapter 7**. Note the angle of the trunk. In this example, it's twisted slightly to the left. So the rest of the trunk parts are towards the left.

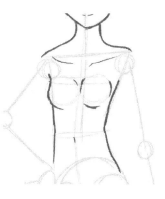

For the arms, draw the ovals with the width that you prefer. Then draw the outline of the arms and the hands.

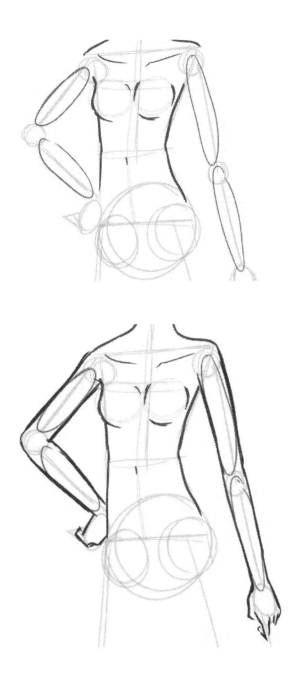

Do the same with the legs. Apply what you have learned so far in drawing the ovals of the legs. Then draw the outline of the legs and the feet.

If you're following this example, it should look similar to what's below.

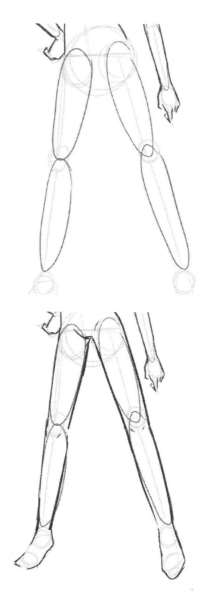

After drawing all those, you should be able to see the character coming together. We still haven't put any clothes on the character yet so you could see how to draw the plain body.

It is fundamental when you're already drawing the clothes... This you will see and learn in the next chapter.

Erase the draft lines and if there are things to adjust like the hair or unconnected lines, it's time to apply the adjustments and corrections.

Also, shown below is a black and white, and colored version of the final drawing of the character (still without clothes).

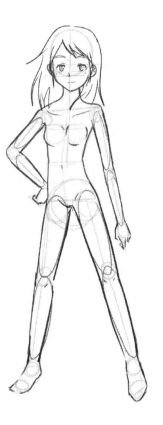

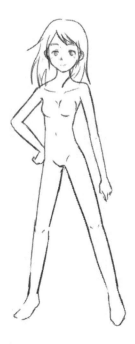

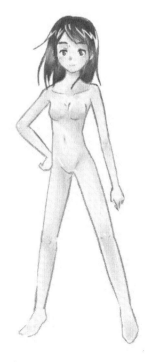

Chapter 9

Designing your Character— Clothes, Accessories and Shoes

What's a character without the clothes? The clothes define from what place and time the character is from. For example, if the character is from a fantasy world of magic, the clothes should look like it's from that place—maybe a wand or a stylish magical clothes would do.

Designing the clothes for your character is one of the most fun parts of drawing the character. Here, you'll be able to experiment and try out different styles for your character, may it be simple or complex.

In this chapter, how you'll learn drawing the clothes is divided into three parts: the actual clothes, the shoes, and the accessories. After covering all those, an example of how you'll draw it in the actual

character will be shown and from then on, you can play around and experiment on your character.

Have fun!

Actual Clothes

First of all, decide on the clothes you want your character to wear. On a separate paper, draw a draft or a sketch of clothes. Here are some examples of drafts. It can be as simple as sleeping wear.

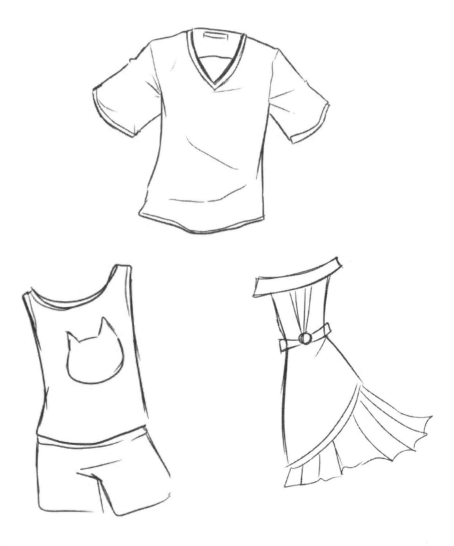

How to Draw the Clothes in the Character

This is why we studied first how to draw the body of the character rather than skipping to drawing the clothes over it. It is because the clothes are worn so it's obvious that the body should be learned first.

Before adding the clothes, drawing how the body of the character should look like is done first. The character might have muscular frame or (as shown in the example) a feminine curvy frame.

Starting with the plain body, draw the outline of the clothes outside the outline of the body. This way, the body shape and movement would affect how the clothes are drawn (as it should be).

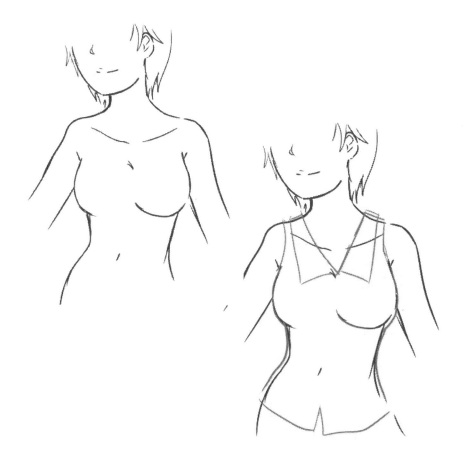

Afterwards, erase the outline of the body within the outline of the clothes. Then add the details of the clothes. You can add the buttons, folds, designs, etc.

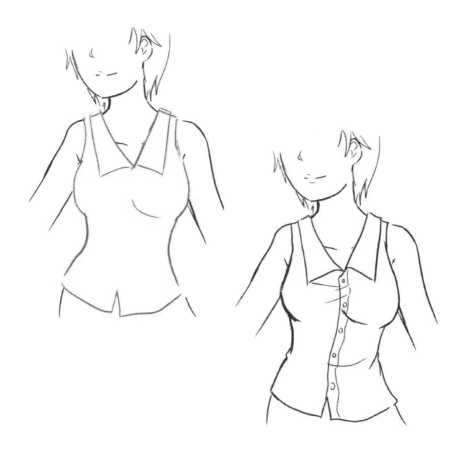

This is the general principle in drawing the clothes onto the character. The next topics would be about how the folding of the clothes happens and how you can draw it.

One issue that the beginners have trouble with is the folds. When the character poses or moves, it causes creases and folds on the clothes. One way of identifying how to know where to put the folds is to consider the law of gravity, the character movement, the design of the clothes and the environment.

Yes, you read it right...the law of gravity. Since the earth has a magnetic pull on everything on it, clothes are obviously included. Shown below is an example of cloth fold being affected by the pull of gravity or the downward pull.

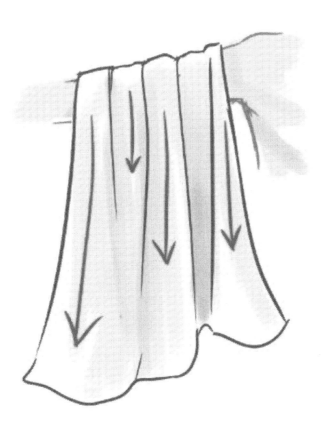

That is why when you're drawing a skirt, it doesn't just show as a triangle. Rather, the gravity pulls it downward and causes it to fold gently and flow downwards.

 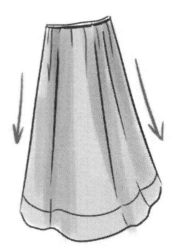

The character movement also affects the fold of the clothes. For example the character lift her arm while a cloth is draped on her arm and shoulders, it would definitely cause a fold to happen. The direction of the fold is away from the arm towards the body. And of course, gravity has an effect on this making the fold curved down. This principle also applies to t-shirts and other tops especially when they're loose.

In the T-shirt example, not only does the arm movement cause the sleeve to have folds, it also pulls some cloth in the whole shirt. This causes also folds toward the lower part of the sleeve (in the "arm pit" of the shirt).

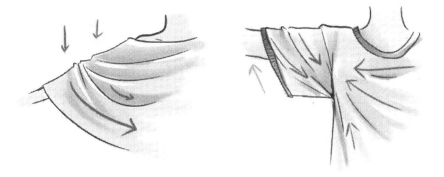

Another movement that affects the fold is the movement of the trunk and the legs. In the example below, you can observe the movement of the girl's body—chest out and the buttocks bent towards the back. This pulls the cloth in the waist to be pulled forward thus the cloth is folded towards the waist from the front part of the dress (the most pulled part). Then the cloth folds that accumulated at the back is affected by the gravity so it flows down. To depict a swinging motion of the girl, an additional fold movement was added thus the fold swings toward the front.

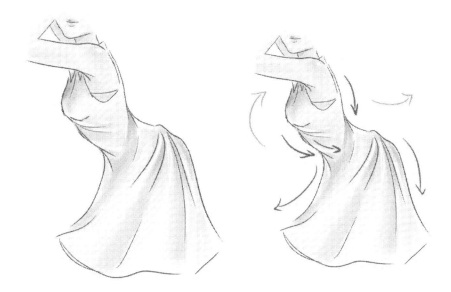

When it comes to the pants, the fold is mostly influenced by the bending motion of the knee and the hips. It is also influenced by how tight or how loose the pants/shorts are.

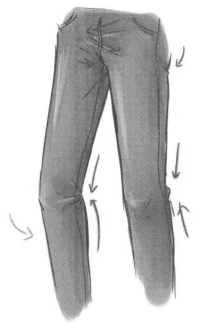

On the left is an example of tight pants and how it is drawn. Since the pants is tight, a slight movement of the legs already affects the fold of the pants. However, the degree of folding is limited since the pants is tight.

When the knee bends, the cloth from the upper and lower part of the back of the knee accumulates and thus folding occurs towards the back of the knee from the side of the knee.

As for the hips area, when the hip joint moves it not only affects the front but also the back as well. When it bends back, the cloth accumulates towards the back and into the lower part of the buttocks.

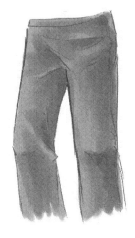

When the pants is loose, the degree of folds are large since there's not much limit. But you'll barely notice the bending movement of the legs because it is loose. It is also similar as the one before (the tight pants) but the loose pants is more influenced by gravity.

The thickness of the cloth also affects the folds. The thinner the cloth, the thinner the folds are and the easier it folds.

This is shown below. The sweater in the left side is thick so the folds are lesser. And also, you can observe that the outline of the sweater is farther from the skin itself—depicting thickness of the clothes.

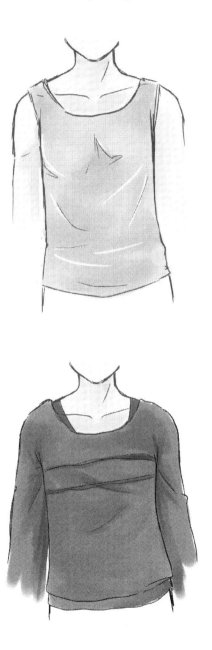

Accessories

Accessories add color to the character's style. It includes hat, earrings, neckties, bowties, bracelets, glasses, etc.

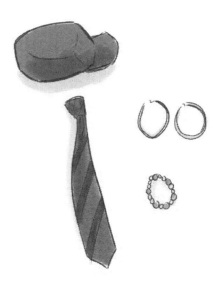

Have fun with it. Experiment on how you want your character to look like. You may want to accessorize your character into a princess, or into a gothic chic, or into a perfect gentleman.

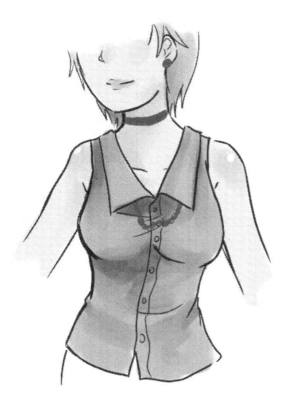

There are no limits on how you can design your character's style. Accentuate them with accessories and it'll also help to give them a personality based on the accessories.

Shoes

Shoes is essential to a character's costume. It serves as foot wears as well as it gives appeal to the style of the character. For an example, an athlete style cannot go away without the sports shoes, or an office lady without her heels.

Here's how to draw them.

Start off with the outline of the feet. This should be drawn lightly using a pencil. Then draw over it using a darker pencil or a pen (if you're good at not having any erasures) the outline of the shoes. Note that you should draw outside the outline of the feet.

Then when you have drawn the outline and are sure about it, erase the draft for the feet and finalize the drawing of both the shoes and the feet. You can add more details such as scratches on the shoes or socks.

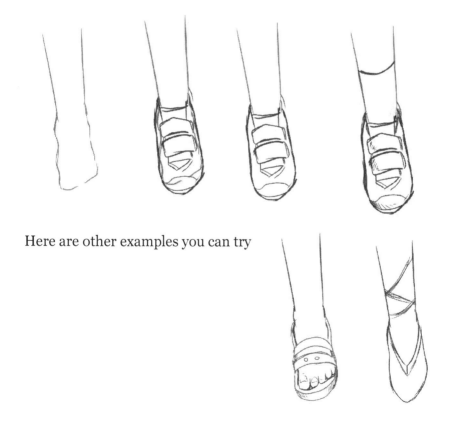

Here are other examples you can try

But how can you draw the shoes in side view? Here's how.

Using similar principle, draw the shoes outline outside the outline of the feet (drawn lightly using a pencil). Note that the surface is straight. After drawing the outline of the shoes, add the details of the shoes such as the heel shading and the design. Erase the unnecessary and unwanted draft lines, and finalize the outlines of both the shoes and the feet.

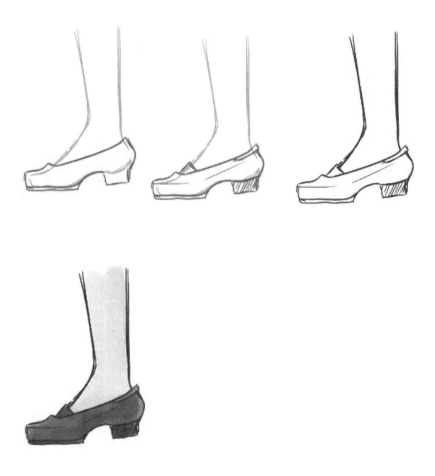

There you go. Combine all these to "dress up" your character. There's no hard thing in clothes as long as you know and consider all the effects it might have on the character's clothes.

Also, never forget to draw them outside the character's body because the clothes are worn. And if the clothes is loose, increase the distance between the skin the clothes but still keep note of the gravity—which means, the clothes on the shoulder wouldn't have much distance from the shoulder part of the clothes. But rather, the clothes won't be that body fitting when loose.

If you are having a hard time drawing clothes, try to take a picture of you or other people wearing the similar clothes you want to draw. Then observe how the movements and the environment affect how the clothes are folded and formed around the body.

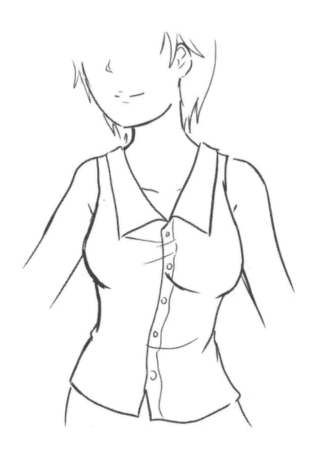

Endnote from the
Andrew Harnes

What you have learned are just some of the many techniques in drawing anime but these are the easiest ways I can think of to teach you how to draw your own anime character. They are just the basics and colors are not yet included as they are to be learned when you have mastered how to draw the anime in black and white.

I hope you enjoyed learning how to draw using these techniques and develop also your own style. One way of doing that is to observe (not copy if you want your own style) the styles of anime/manga artists. You'll determine which art styles are appealing and which ones aren't, and when you do, try to infuse that to what you already know. For example, the art style uses irregular thick lines around

the outline of the body, try infusing that with your way of drawing and see what happens.

Drawing anime is changing through time and as artists develop different kinds of styles. Don't be afraid to experiment. And don't forget to have fun.

Made in the USA
Lexington, KY
06 December 2016